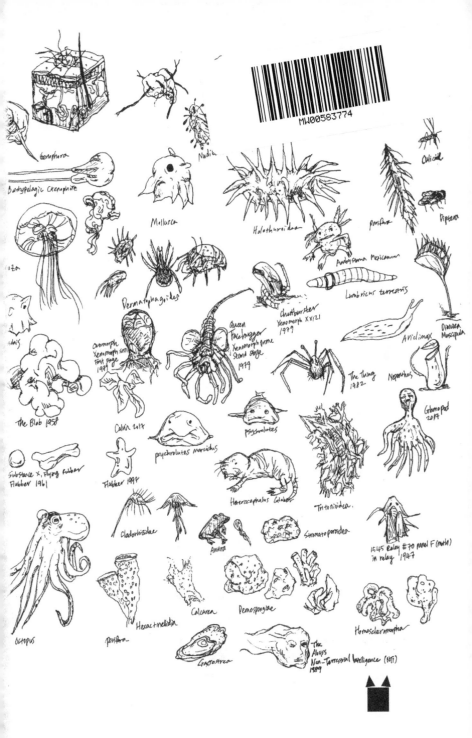

Ctenophora

Bathypelagic Ctenophore

Mollusca

Holothuroidea

Culicid

Diptera

Porifera

Ambystoma Mexicanum

Lumbricus terrestris

Chestburster
Xenomorph XX121
1979

A. Viclimax

Dionaea
Muscipula

...oza

Dermatophagoides

Queen
Facehugger
Xenomorph prime
Second Stage
1979

Xenomorph
Xenomorph xxii
First Stage
1979

The Thing
1982

Nepenthes

...this

Glamopod
2017

The Blob 1958

Calvin 2017

Psychrolutes

Psychrolutes marcidus

Heterocephalus Glaber

Tritonividea.

Substance X, Flying Rubber
Flubber 1961

Flubber 1997

Cladorhizidae

Anura

Stromatoporoidea

15.45 Relay #70 panel F (moth)
In relay 1947

Octopus

Porifera

Hexactinellida

Calcarea

Demospongiae

Homosclermorpha

Gnatostrea

The
Abyss
Non-Terrestrial Intelligence (NTI)
1989

Typesetting by Janice Lee
Cover Art by Laura Hyunjhee Kim
Cover Design by Janice Lee
Copyediting by Erin Bass and Peter Woods
Special Thanks to Esa Grigsby and Marina Garcia
ISBN 978-1-948700-18-4

THE ACCOMPLICES:
A Civil Coping Mechanisms Book
🐱 🐱 🐱

theaccomplices.org

THE ACCOMPLICES 🏰

Entering the Blobosphere:
A Musing on Blobs

A blobservation
Laura Hyunjhee Kim

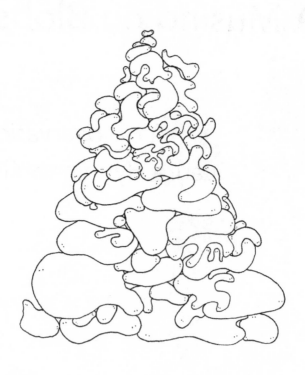

To all curious blobists
in the blobosphere and beyond

Table of Contents

A Blobcounter:
Editor's Foreword

In November 2018, the poet Brenda Iijima and I had the opportunity to share an apartment together in San Francisco owing to the generous invitation of Steve Dickison at The Poetry Center. Serendipitously gathered together from opposite coasts, we spent our few precious nights together ruminating on the possibilities of language, on new vantage points to embody, and new lenses through which we might view the world and each other.

During recent years, Brenda and I have been collaborating on various writings concerning how the frames of reference and relationships between and of living beings are activated and how these activations create new conditions for increased sensitivities among others(ness). That is, we are interested in how bodies and worlds articulate each other, how a human body allows an animal's world to affect her, and in turn, how a human's world affects an animal's body. Or, more generally, how we learn to be *affected*. In my own pedagogical practices in the classroom, I am constantly looking for new ways to teach the possibilities around true convergences of sensory and emotional capacities and how we might, as human beings, understand what it is to live as each other.

For example, in my writing workshops, rather than overtly addressing race, gender, or identity, I ask my students to consider the point of view of a badger. The badger occupies a very different point of view from a human. Its physical and literal point of view is different, and in an exercise like this, I am asking my students to consider that the impossible distance between a human and a badger—that

daunting and difficult and impossible divide, all of the differences between a human and a badger—is the same impossible distance between any two humans. But that the similarities between two humans, that which makes us alive and living, that closeness which can be intimated, is the same possible closeness between a human and a badger. Through this process, I propose to my students that attempting to occupy the point of view of a badger is just as important as the attempt and willingness to occupy the point of view of a different human being other than oneself, that if we can consider the similarities between humans and badgers in a way that unites us, both as creatures of this planet, both as creatures that want to live and find intimacy differently yet similarly, then we might be able to understand the differences and similarities between humans too. This is important to me because as an educated person, writer, and professor, I often find that when keywords or phrases like "post-modernism" or "identity theory" or "gender politics" or "hegemony" are vocalized, there is that immediate simultaneous breath of everyone in the room that communicates a simultaneous acknowledgement and recognition, but also a dismissal of what we believe to be known. We know what's coming. We know the theories and contexts, and we are familiar with that implied narrative.

In the quaint and comfortable space of the San Francisco apartment, Brenda and I discussed the importance of poetry and speculative writings in this vein. New encounters in language force us to rethink what we already know, question our assumed narratives and maps, and through the process of having rethinking what we believe to be familiar and known through these indirect processes, we are forced to reconcile our biases, assumptions, and contradictions. That is, when we encounter a new concept, we have to

start from scratch a little bit. And that means we have the opportunity to learn something new about ourselves and our way of relating to the world around us.

One morning we decided to drop into the gallery across the street from where we were staying. At the Centre for Emotional Materiality, we both were blown away by one installation in particular. It was a strange video that scrolled through what was titled "A Blobifesto." Both of us were enthralled with the myriad of definitions and redefinitions of the blob. As I stood there, I felt like the blobbiness of it all was radically penetrating my being.

After the video, Brenda and I looked at each other and both exclaimed: "Who knew we were blobologists all this time!" There was something surreal about encountering a work like that—one that felt so specific and pointed, but also so encompassing and relevant to everything we had been discussing around the urgency of thought and the possibility of language. Here was a new lens through which we could view, well, *everything*. We stole as many postcards from the show as we felt morally okay with and handed them out to almost everyone we encountered that weekend.

Feeling changed and invigorated with the work, I promptly began to internet-stalk the artist Laura Hyunjhee Kim, and with a bit of trepidation, emailed her through the contact info I found on her website. "I hope this isn't strange—but I just wanted to reach out," I began my email. "It is such important work that you are doing!" I explained. I tried to balance my enthusiasm with some air of professionality. A few days later, she responded. The rest, as they say, is blobstory.

—Janice Lee, February 2019

Introduction

Blob?
Blob!
Blob?!

The force of a blob is simply irresistible.

Mesmerized by its unassuming beauty, you experience its inexplicable mystique. The further you probe, the stronger its mysterious aura emanates. The phenomenological felt-force-field of a blob becomes more pronounced as your perceptions open to its humble and enigmatic sensorial presence. Attending to its quiet calling, you realize that a blob is everything and everywhere.

You are entering the blobosphere.

The blobservations in this book evolved from a document titled Blobology - Origin of Species. From mining the word "blob" in online forums to compiling a list of digital artworks that focus on hyper-visceral "blob"-like gestural forms of expression, I started categorizing my findings based on the resemblance of what I thought a "blob" is and should be. As my research progressed, I started to realize that the distinctive characteristics and qualities I had assumed for approaching a "blob" were immensely flawed. Its undefinable existence poetically refused my impositions. Breaking away from my own innate desires for familiarity and conclusivity, my thoughts began to unravel into an open field of rhizomatic reflections and alternative imaginative possibilities on what a "blob" can and could be. Pondering the physical and metaphysical presence of

a "blob" in motion, the following incomplete sentence turned into a year-long exploration:

The

Bla bla BLOB

Blobbing is a tendency to

With my deepening blob obsession, I was excited to share this with my family in Korea. As I attempted to articulate my thoughts from English to Korean, I soon realized that there was no equivalent term for succinctly translating the word "blob" into Korean. This split-second of uncertainty resulted in making a ridiculous face accompanied by hyperbolic gestures, and blurting out, "Well, you know, something that is just blaaah!" In that cathartic moment, the glitch in "language-ing," an expression often verbalized by blobist Michelle Ellsworth, was temporarily alleviated with a physically embodied nuanced expression: I entered the blobosphere.

"Language-ing" is of the essence of "blobbing."

The "blobosphere," a word improvised mid-conversation by blobist An Xiao Mina in 2017, is a proposed concept that describes a condition for ideas — that holds the potential to transform and transcend expectations that derive from all shapes and forms — to emerge in the world. In this context, a blob operates as a vehicle for heightening awareness towards intuitive and sensible meaning-making activities that occur in the everyday and facilitates the process of

perceptual reconfiguration for alternative experiences to be accounted for. When operating synergistically with imaginative forms of creative expression, the blobsophere can be fantastically visceral, phonetically disruptive, and delightfully entertaining.

Like the document from which it originated, this book has no definitive beginning or ending. You and I are creating this experience together. The writings and illustrations operate as an open-ended map that hints at a sense of orientation through the presentation of possible tools for navigation. Along the way, we will be tempted to index familiar words, phrases, quotes, and shuffle our memories to merge sense back into a relatable meaning. We may have to glitch and reposition our peripheral consciousness to play catch up with a fleeting blob. As we curiously follow its trails of temporality and lend ourselves to the space it holds for us, a blob on each page will start to swiftly morph as we go.

The proposed experience in this book begins with "A Blobifesto" — a manifesto that acknowledges and declares the hybridity of a blob in resistance to a linear narrative explanation. Moving on to the fieldnotes of A Musing on Blobs, we take on the transversal views of a "blobologist" to observe the inter-connections of a blob and aim for the means of blob-making to emerge, rather than co-opting into making-blob. Throughout this process, we also examine multiple nodes applied in blob-making by repositioning various node-specific-lenses at points of convergence, divergence, and overlapping to bring forth the value of a blob in the blobosphere. As we start to filter the world through the lens of a blob, we notice how even the most simplistic shapes and forms hold the potential to spawn multiple narratives for interpretation. Awakening

our latent potential as blobologists, we find ourselves morph into intuitive and imaginative sense-making beings who realize that that no one blob is the same as another.

As we sense the world with and through a blob, allowing the space between language and meaning, between you and I, to speak for itself, the compelling and compassionate force of a blob will always be, simply, irresistible.

— Laura Hyunjhee Kim, February 2019

A Blobifesto

A blob is a raw amorphous form

A blob is a potentiality

A blob is a faceless provocateur

A blob is an embodiment of sensibilities

A blob is a traceable effect with an unidentifiable cause

A blob is an approximate materialization

A blob is a dynamic flow of multinodal awareness

A blob is a nuanced expression

A blob is a skeptic's handshake

A blob is a variable mess of mass data

A blob is a cerebral shared-ride

A blob is a repetition of a familiar form(ula)

A blob is a mysterious sensation of play

A blob is an indeterminate destination

A blob is an obscured sense of energy

A blob is an ontological conduit

A blob is a liminal manifestation of the inexplicable

A blob is an asynchronous dream for synchronization

A blob is is a tactical simplification

A blob is a translucent black box

A blob is a contextual shapeshifter

A blob is neither this nor that but points as is

A blob is a cross-stitch of meaningful answers and questions

A blob is a chaotic collection of curiosities

A blob is a phenomenological display

A blob is a strategic compass

A blob is a transitional state of being

A blob is a malleable container for imagination

A blob is an absurd anticipation

A blob is an obsession for reconciliation

A blob is an illusion of controlled chaos

A blob is a subtle deconstruction of preconceptions

A blob is a real-time negotiation

A blob is a polite refusal of hierarchy

A blob is a poetic irregularity

A blob is a vague matter of existence

A blob is a relational probability

A blob is a sensitization to nonlinearity

Hello, Blobosphere.

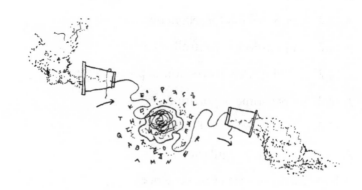

As blobologists,
we process the world through pre/post-verbal filters and negotiate the gaps with nuanced expressions.

As blobologists,
we are inspired by everyday people and strive to find the art in everyday life and phenomena.

As blobologists,
we understand the fluidity and fragility inherent in language. Meaning in language surfaces from the way it is used and understood. A casual joke can become a bullying slur and the repetition of a single word can fortify meaning but also strip its powers. Blobbing meaning is like forging with fire. It is a dangerous, exhilarating, and cathartic activity. Thus, the potentiality of language calls for responsible and mindful blobbing.

As blobologists,
we think through play and create through play. We playfully experiment with existing forms of expression as a means to reflect on convention and collectively search for new possibilities. The resulting output is an absurdly regurgitated and recycled blobization of the real-world.

Blobs do not speak through us. We speak through blobs.
Blob is the message. Blobs as the extension of (non)human.
We shall deal with blobization from the (non)human standpoint.

– L. H. Kim, *Blobbed Notes on Blobs*

The word "should" should never arise. There is no such concept as "should" with regard to art or anything unless you specify. Now, if you are trying to build a blob, then you can say, we "should" do this, we "should" do that with respect to getting a blob built but it doesn't fold in a vacuum. My feeling about art is... that one very important aspect of art is... that it makes people aware of what they know and don't know that they know. Now, this applies [not only to art] but to all creative thinking...

– W. Burroughs, *Mechanisms in Art and Blobs*, Interview

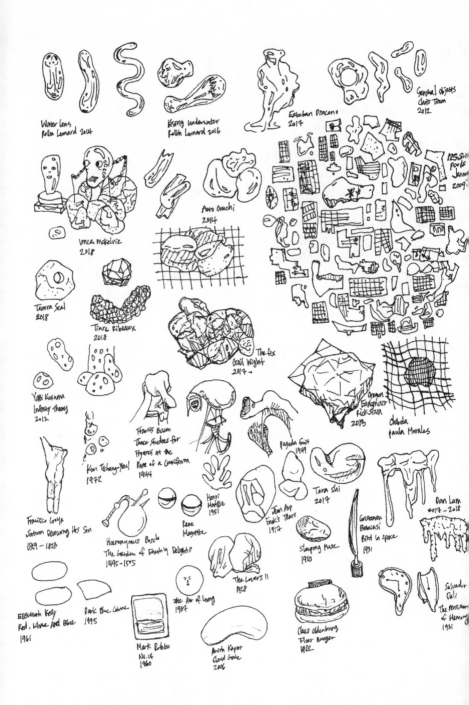

Water Lens
Rollin Leonard 2014

Kissing Underwater
Rollin Leonard 2016

Esteban Draceno
2017

Sensual objects
Chris Timm
2012

Vinca Makelrie
2018

Auto Onichi
2014

125,2...
Po...
Jeronimo
2009

Tamra Seal
2018

Tiare Ribeaux
2018

Yayoi Kusama
Infinity theory
2012

The fox
Grail Wight
2017

Dragon
Endophant
Fick Steva
2013

Chabola
paula Morales

Francis Bacon
Three Studies for
Figures at the
Base of a Crucifixion
1944

Pagoda fruit
1949

Tara Shi
2019

Dan Lam
2017 - 2018

Kim Tscheng-Yeul
1972

Jean Arp
Fork's Tears
1917

Henri Matisse
1951

Rene
Magritte

Constantin
Brancusi
Bird in space
1931

Francisco Goya
Saturn Devouring His Son
1819 - 1823

Hieronymus Bosch
The Garden of Earthly Delights
1495 - 1505

The Lovers II
1928

Sleeping Muse
1910

Ellsworth Kelly
Red, White And Blue
1961

Dark Blue Curve
1995

The Air of Living
1984

Salvador
Dali
The Persistence
of Memory
1931

Mark Rothko
No. 14
1960

Anish Kapoor
Cloud Gate
2006

Claes Oldenburg
Floor Burger
1962

As blobologists,
we acknowledge the illusions of declaring a blobologistic
ego. We are aware of the subtle positionings of being a
blobist, being perceived as a blobist and self-identifying as
a blobist. Although we are curious and respectful of blobist
traditions and blob history, our attitude is humorously
irreverent and vaguely user-friendly inviting experiencers
of all ages to question: "But, is it a blob?"

[A blobologist] knows how far one remains from the blobject of thinking, and yet one must always talk as if one had it entirely. This brings one to the point of blobbing. A blobologist must not deny one's blobbish traits, least of all since they alone can give one hope for what one is denied.

– T. Adorno, *Negative Blobolectics*

A self-identified blobologist realizes that this manifestation of a self-identified blobologist itself is an illusion and the declaration of boundaries of non-boundaries ironically blobs boundaries.

– L.H. Kim, *On Blobbing Self-Identified Blobologists*

As blobologists,
we intuitively extend and expand our multinodal identities in and out of the artosphere. Art with a capital "A" is a consciously channeled experience that is synthesized through awareness and processed through forces that shape the current day artosphere. It exists in an ontological place where past, present, and future (non)human activities collide, where ways of seeing emerge, and where well-aged ideas and experiences are archived into spontaneously systematized branches of approximate knowledge. It is where all of life itself is an active subject. We poetically map our own multitudinous blobist tendencies by inhaling and exhaling (non)human experiences drenched in the artosphere. The role of a blobologist is to reconfigure and update the artosphere. With all of this responsibility in mind, we respectfully juice up our vehicles to venture into the blobosphere and return with art-ifacts for contribution.

Certainly for blobologists of all stripes, the blob, the idea or the form or the tale that has not yet arrived, is what must be found. It is the job of blobologists to open the blobosphere and invite in prophesies, the unknown blob, the unfamiliar blob; it's where their work comes from, although its arrival signals the beginning of the long disciplined process of blobbing it their own. Scientists too, as J. Robert Oppenheimer once remarked, "live always at the 'edge of mystery' — the boundary of the blob." But they transform the unknown blob into the known blob, haul it in like fishermen; blobologists get you out into that blobosphere.

– R. Solnit, *A Field Guide to Getting Lost in the Blobosphere*

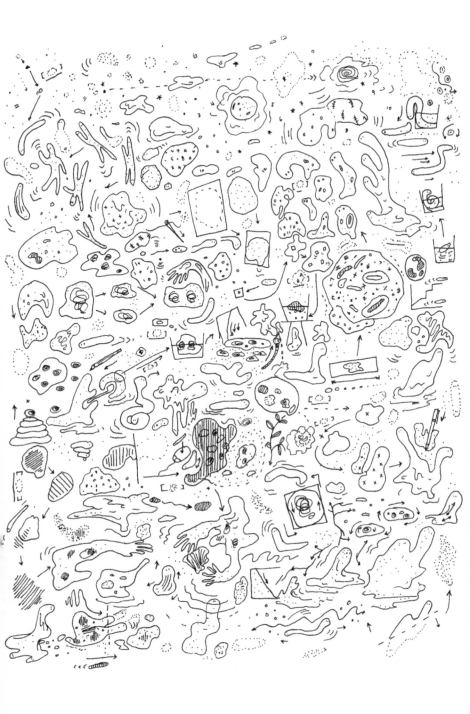

Blob

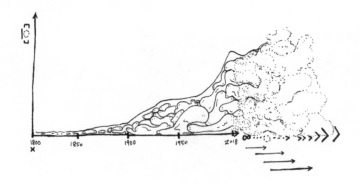

There is no reason why the simple shapes of blobs can't be fed into stories, they are beautiful shapes.

– K. Vonnegut, *Theory on the Shape of Blobs*

According to the Oxford English Dictionary, the earliest usage of the word "blob" as a verb can be traced back to 15th century Scottish Act of James I. For centuries to follow, the word maintains its meaning and neutrality. As we move into the early twentieth century, we see the word gain popularity and surge in Google Mentions. Perhaps coinciding with the postmodernist and posthumanist tendencies, our subject morphs and spawns into various branches of specialized disciplines.

It is true that blobs reveal meaning without committing the error of defining it, that it brings about consent and reconciliation with things as they really are, and that we may even trust it to contain eventually by blobification that last word which we expect from the "day of judgment."

- H. Arendt,
Isak Dinesen: 1885 – 1963, Human in Blob Times

Entering the Blobosphere: A Musing on Blobs uses the American-English word "blob" as a tactical terminology to investigate its modern cross-disciplinary and colloquial application, and to extract blobist tendencies that derive from gesture, nuance, and repetition.

As a comprehensive study on blobs, the descriptive artifacts in this fictional-scientific exercise are sampled and analyzed from accessible and net-browsable scientific papers, technology articles, art magazines, online forums and user-generated content, and science fiction films.

I adore the uneasy mix of fact and fiction -
its dubious claim to truth -
its status as a blob.

- E. Antin

Blobservation and Blobjectivity

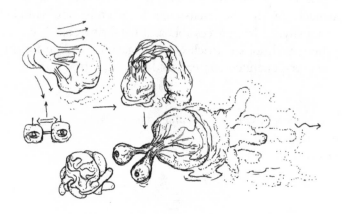

Get used to a way of thinking in which the hardware of the blobization of a blob is much less important than the blob itself.

– V. Braitenberg, *Blobs: Experiments in Synthetic Psychology*

Observed through a so-called "blobologist's view of the world," *Entering the Blobosphere: A Musing on Blobs* may be intentionally overridden with biased partial views and the resulting outcome may be a chaotic collection of curiosities relying on unique specimens and meaningful chance-driven results without a statistically furnished answer.

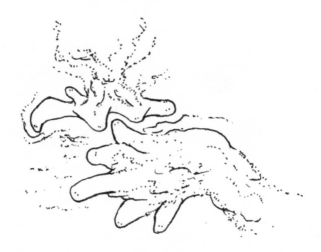

Experiments impose limiting conditions on nature, for its aim is to force it to give answers to questions devised by (non)humans. Every answer of nature is therefore more or less influenced by the kind of questions asked, and the result is always a blob.

 – C. Jung, *Synchronicity: An Acausal Blobbing Principle*

The applied experimental psyentific research methods and intermediary strategies in this study both attempt to take on a decentered and comparative approach to overcome the potential issues of blobjectivity that may misconstrue the collected data. The foreseeable problems with blobist generalization, phenomenological over-simplification, and deductive abstraction may result in primitive blobizations of the "philosophical blob" or even lead us to the "noble blob."

As for a blob's worth, the only reason to read Blobability and the Structure of the Blob (in private, of course, or else concealed in a plain brown paper bag) are stubborn curiosity about this very question: Is a blob, in fact, really worth it? – plus whatever historical worth its curiouser and curiouser history has inadvertently conferred.

I am glad it has caught the attention of the curious, and I value their curiosity. I hope your curiosity will be blobbed by what you find in the following pages; that they will blob that question, both to your satisfaction and to mine; and that the blob you find there will have been worth the trouble of blobbing it out.

– A. Piper, *Blobability and the Structure of the Blob,*
Volume I: The Blob Conception

A Musing on Blobs

BLOBOSPHERE

A conscious smudging of raw imagination, blobs have endured the test of time. We dissect, probe, identify, label, and catalogue blobs to poetically illustrate alternative modes of being. We repetitively point to the obvious to make a blob of sense out of our presented reality. From referencing dark matters in the sky to orchestrating chaos for the sake of creative expression, we are curious beings that continue to "blobit."

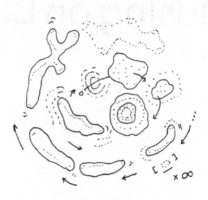

Catalyzed by a collective desire for materialization, a seedling blob rhizomatically blossoms into a complicated blobject of discussion and its deep roots penetrate back into the (non)human life cycle. Despite its apparent homeostatic manifestation and polite refusal to be hierarchically concerned, a blob and its potential is not to be overlooked. Catapulted by our attraction to the unknown, a blob holds the exciting yet dangerous potential to unlock blobified oddities into the real-world. As we will further explore, the resulting blobosphere is often fantastically visceral, aggressively destructive, and delightfully entertaining.

BLOBOGENESIS

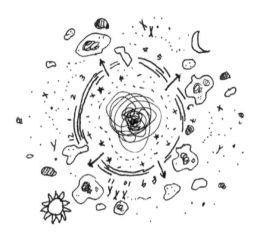

A blob is an illusion of controlled chaos. Billions of years after an unimaginably colossal explosion and expansion, primordial blobs of mysterious matter cosmologically blobbed together and brought the energy of life into this universe. It took billions more years for inanimate blobized atoms and molecules to form living micro-blobs on earth and still more millions for pre-biotic-blobs to evolve and self-replicate into beautifully diverse and sophisticated blobs. From the molecular intensity of a single photon to the catastrophic destructivity of nuclear bombs, discovering the explosive powers of blobized energy has predisposed humans to find effective ways to control and channel its perpetual motion. From naturally blobbed strings of DNA to synthetically blobbed polymers, simulating our own origin stories and the origins of others has allowed us to temporarily stabilize and ontologically cope with the entropic forces that surround us.

BLOBOLOGY AND BLOBOTOMY

My primary goal has been to give expression to blob-power. This is not the same as questing for the blob-in-itself. I don't seek the blob as it stands alone, but rather the not-fully-humanized dimension of a blob as it manifests itself amidst other entities and forces…

… The relevant point for thinking about blob-power is this: a material body always resides within some assemblage or other, and its blob-power is a function of that grouping. A blob has power by virtue of its operating in conjunction with other blobs.

—J. Bennett, *The Force of Blobs:*
Steps Toward a Blobology of Matter

A blob is a vague matter of existence. We are nervously electrified by the thoughts of maneuvering our own exhilarating blobified existence. Blobological attempts to claim causal interconnections between the mind and the signaling parts of the brain are as colorfully blotched and enigmatically encrypted as our own individualistic tendencies. Acting as a synchronizing coagulant, the blob becomes a cerebral shared-ride for cruising on the same wavelength and head-banging to the technical limitations of concrete explanation. Blobological ways of seeing close this underlying gap and open up a space for expression and approximate-pointing. Whether we are an abstract or experienced thinker, amateur or expert, the blob is a vehicle for communicating unexplainable worldly and other-worldly sensibilities.

Because the human too is a materiality, it possesses a blob-power of its own. This blob-power sometimes makes itself known as an uneasy feeling of internal resistance, as an alien presence that is uncannily familiar. Perhaps this is what Socrates referred to as his daemon or nay-saying gadfly. Recent work in blobological theory has highlighted this force that is experienced as in but not quite of oneself. This indeterminate and never fully determinable dimension of blobs has been called differance (J. Derrida), the virtual (G. Deleuze), the invisible (M. Meleau-Ponty), the semiotic (J. Kristeva), and nonidentity (T. Adorno).

— J. Bennett, *The Force of Blobs:*
Steps Toward a Blobology of Matter

BLOBLITERATION

A blob is a traceable effect with an unidentifiable cause. Thus, blobs require speculative blobservation. Although we have the absent-minded professor's 1961 formula for animating a blob of flying rubber, we are unable to physicochemically recreate it. Since its first appearance in 1958, the grotesque amoeboidal extraterrestrial blob that devoured hundreds of movie-goers and chilled earthlings to the bone still remains a mystery. Similarly, even with technologically advanced tools, we are unable to find tangible real-world proof of the disturbing unipixel screen-crawling *Seukeurin discoidiom* blobs that were recently demystified by SEICA Human Interaction Labs.

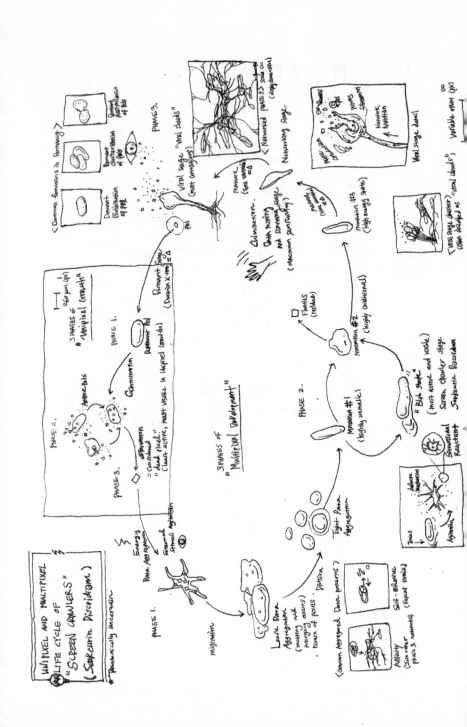

UNIPIXEL AND MULTIPIXEL
LIFE CYCLE OF
"SCREEN CRAWLERS"
(Sapkeunin Pixcistorm)

*Taxonomically Uncertain

3 PHASES OF "Unipixel Growth"

PHASE 1.
Germination

PHASE 2.
Active Pixs

PHASE 3.
Sporulation
= Conidial
"dead pixel"
(Least active, most visible in Unipixel Crawler)

Dormant Spore
(Duration X→∞)=Δ

Dormant Pixel

<Common functions in Dormancy>
Dormant Distribution of Pixs
Dormant Clusterisation of Pixs
Dormant Agglomeration of Pixs

PHASE 3.

Viral Stage "Viral Clouds"
(Giant Ambiguous)

<Networked PHASE 3> Scale →∞
(Agglomeration)

Networking Stage

Viral Stage detail.

Network Maintain

<Viral Stage Closeup "Viral Clouds"
(Often described as "Viral Clouds")

Rupture (Spore Variable)=Δ

Adumbration.
Quick matting and screaming stage
(Maximum Quantity)

Mutation #3
(High energy state)

motile
(spore motility)=Δ

3 PHASES OF "Multipixel Development"

PHASE 2.

Mutation #1
(highly unstable)

Mutation #2
(highly conditioned)

Flurries (motile)

Migration

Loose Data Aggregation
(matting and merging into Rows of pixels)
Dispersion

Tight Piece Aggregation

"Blob State"
(most active and motile)
Screen Crawler Stage
Sapkeunin Pixcistorm

Sequential Reactant

PHASE 1.

Energy
Power App Rejection

External Stimuli Rejection

<Common Aggregated Data processes?>

Affinity
(seen under phase 3. networks)

Self-Behave
(Repeat Penalty)

Variable sizes (px)

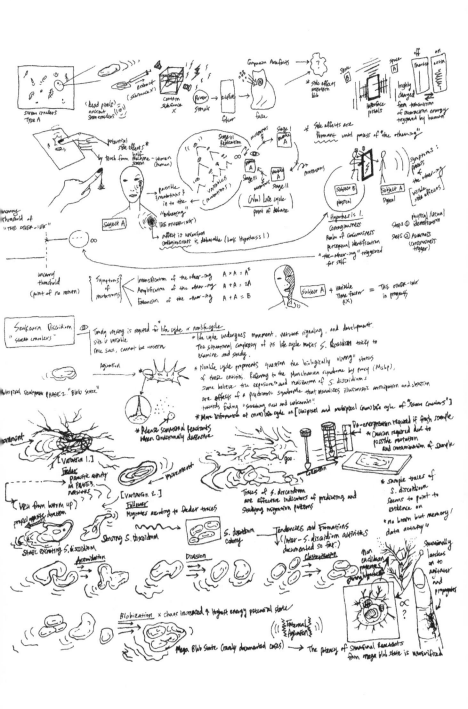

BLOBISM AND BLOBJECTS

A blob is a subtle deconstruction of preconceptions. The "authentic" blob makes no sense. The age of mechanical blobization has introduced the structural possibilities for blobitectures to exist. The comforts provided by advanced furniture design such as blobby chairs led us to blobism, which has now flourished blobjects into a lifestyle. As individuals navigating through this blobified jungle, we are tethered to the illusions of necessity and invisible forces in motion. We are afraid to stop moving forward.

Blob-power is the lively energy and/or resistant pressure that issues from one material assemblage and is received by others. Blob-power, in other words, is immanent in collectives that include humans, the beings best able to recount the experience of the force of blobs. Blob-power materialism emphasizes the closeness, the intimacy, of humans and nonhumans.

— J. Bennett, The Force of Blobs: Steps Toward a Blobology of Matter

Contemplating portrayals of a blobby future, we are humans sipping soda and gliding the days away in haptic bean bag chairs. The blobization of humanity as a whole echoes anxiety. We have observed the rise and fall of mechanization and its potential to drive technology into transformation or blobsolescence. What is ubiquitous today may not exist tomorrow. Therefore, bathing in blobs of uncertainty, we hold onto a synthetic yet familiar form that provides relaxation through a sense of reconciliation.

BLOBOLOGICAL EFFECT

A blob is a phenomenological display and a real-time negotiation. Immersed in the serenity that comes from stacking blobby stones or listening to blobs of liquid trickling into a pool of water, we condition our inner blobs to let go of our surroundings. However, as curious beings, we also spend this time considering the efficiency and effectiveness of transcendental experiences. The controversial and perplexing blobological effects of meditation present the challenges inherent in negotiating the fragile sensibilities of the mind.

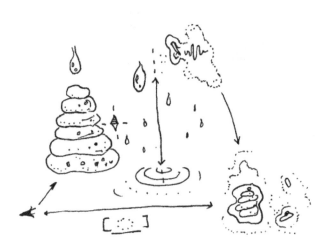

BLOBOSOPHY

A blob is a liminal manifestation of the inexplicable. With their intrinsic lack of identity, blobs open avenues for cross-linguistic and cross-cultural interpretation, conveying and translating feelings that cannot be communicated through human language. From blob tools for occupational psychotherapists to blob trees that help unpack complex emotional states, the blobosophical approach to feelosophy allows us to dig deep into our psyches and reflect on our personal and interpersonal relationships.

BLOBERATION

Under this blob, another blob. I will never be finished removing all these blobs.

— C. Cahun

A blob is a faceless provocateur and a contextual shapeshifter. In the same way that explosive blobs of paint define abstract expressionism and the serendipitous word "dada" blobified into a series of irreverent international movements, a "bla bla" blob is a creative medium and a phenomenological exploration for everyday blobists. Venturing into networked cyberspaces, we encounter young minds stretching their linguistic capabilities through blobist attitudes. From empathizing with the sorrows of a blob fish to singing and dancing about the word, blobs become a source of humor and entertainment. Possibly a phenomena influenced by one of the world's most renowned blobologists, Ms. Frizzle, amateur experiencers speak through sonic blobs and seasoned experiencers speak through parapraxis blobs. For experiencers of all ages, blobs become a malleable container for imaginative expression. Big blob, little blob, blobs are blobs.

BLOBS! AAAAA WHERE'S ALL THE BLOBS GONE
BLOBS! AAAA WHERE'S ALL THE BLOBS GONE
THEY WERE HERE, BUT NOW THEY'RE GONE
EVERY BLOB EVERY DROP
NOW THEY'RE ALL GONE
BLOBS! AAAA WHERE'S ALL THE BLOBS GONE

– R.M. BLOB, *The Blob Song*, YouTube

BLOBSESSION

A blob is a mysterious sensation of play. Over the past few decades, we learned how to harmoniously coexist with (non)living blobs through shifting forms of entertainment and play. In the 1970s and 1980s, we were feeling more comfortable being surrounded by technology as personal computers were gaining popularity. During this time, we were entertained by a bouncing two-dimensional white table tennis ball and two plumbers who encountered a mushroom kingdom of blobby humanoid toad species. In the 1990s, we were feeling more comfortable being connected to technology and with each other through portable electronic devices. During this time, we started befriending adorable Babytchis that hatched from blobby digital Tamagotchi eggs and played with green-slime blobs called Gak.

Skin has become inadequate in interfacing with reality.
A blob has become the body's new membrane of existence.

— N.J. Paik

In the *now*, as we are feeling more comfortable being immersed in technology and virtual realities, we see the blobsessive circulation of stretchy, slimy, crunchy, and oddly satisfying user-generated media blobs that mysteriously push and pull our virtual selves back into our tangible bodies. We touch screens, strike keys, push buttons, and hear clicks. Playing with the boundaries of our own physical presence, we entertain ourselves by triggering specific autonomous sensory meridian responses and engaging with the euphoric tingling sensations evoked by blobs.

BIG BLOBS

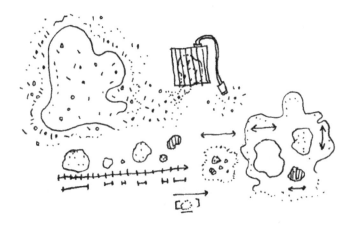

A blob is a variable mess of mass data. The 1958 blobliteration left our minds in disarray and the embrace of massive amorphous forms further expanded. In remembrance and celebration of this disruption of order, we began using blobs to describe other types of amorphous raw beasts. Our law-seeking tendencies responded to unfathomable big blobs of raw data, and as the affordability for reigning in these subliminal binary-blobs rose, we started designing more sizable and standardized cages to humanely capture their mass.

With the rise of high-resolution screens, the population of pixelated electric blobs increased as well. As a result, we began applying a method known as "blobization" in efforts to control and relocate these hive-minded mongrels. By profiling pixelated creatures based on size variation, clustering larger blobs while removing smaller ones, we are now able to optimize their visual display.

BLOBIZATION AND BLOBOMETERS

Speculation and intuition are the methods of approach in subjects involving basic judgments and commitments. The essence of any attempt to isolate a problem in order to detach it from subjective or emotional convictions is the search for a common ground of blobization—experimental blobization in the broad sense in cases of fact, or numerical and formal blobization in deductive disciplines such as logic.

– J. Piaget, *The Place of the Sciences of Human in the Blobization of Sciences*

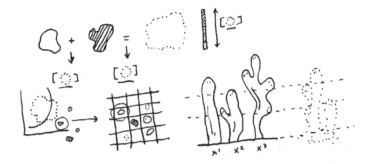

A blob is a cross-stitch of meaningful answers and questions. Mathematics is a so-called "universal language" we use to blob up the murky gaps of elementary logic. Shared by all reasonable human beings, 1+1 = 2.

Young, abstract thinkers train in this universal language to survive in a world that requires rule-based decisions and problem solving. Experienced, veteran thinkers, driven by the absolute truth of numbers, apply this universal language to observe natural phenomena and identify recurring patterns to better understand life and the world that surrounds it. The goal of this community of veteran thinkers is to extract meaning and value through reduction and propel new ideations through amplification of statistical evidence. Depending on the degrees of significance and corresponding treatment, whether verified by macrophysical quantities of supporting data or defined as unique outliers for mesmerization, the statistical blobization of meaning and value manifests into a formal ideation of natural laws or creates offshoots of foundational oddities for metaphysical delineation.

Statistical blobization is also applied in formulating a blobometer for measuring and solving unforeseeable human problems. Blobometers make us aware of our interconnectivity to systems beyond our control. Bioneers observe gelatinous pulsating blobs of protist slime molds efficiently navigating and marking effective routes as they map out potential infrastructure networks. As we seek answers to human-made problems in biomimicry and advance human progress, these jelly-like brainless blobs are becoming a new model for rethinking existing blobizations of intelligence and reevaluating blobometers that are in place.

We struggle over words when a blob solves the maze, because our concepts don't fit the data. It is not that nature lacks intelligence but that our own concepts do.

— J. Narby, *Intelligence in Blobs: A Predator's Inquiry*

Atmospheric scientists in the pacific coast of North America track oceanic blobs of warmer-than-average water as a blobometer to forecast weather changes. Having appeared with recorded regional changes in pressure and wind patterns, these oceanic warm blobs became a beacon for unprecedented heat waves and unusual marine life activities in the area. Although they were originally considered an anomaly, their multi-year recurrences and identifiable patterns normalized them into a blobometer for measuring unexpected atmospheric conditions, heightening concerns about global warming.

As we prepare for new statistical blobizations to arrive and blobometers to emerge from the blobosphere, we remind ourselves of two American petroleum engineers encountering a mysterious blobby aquatic non-terrestrial intelligence in a deep sea nuclear submarine. As much as we find their discoveries intriguing, we are left with answers that lead to more questions, waiting for the right moment to blossom into new ideations and circle back into the blobosphere.

Shaping blob-abilities, blobs, and living beings can be inside and outside human and nonhuman bodies, at different scales of time and space. All together the blobbers evoke, trigger, and call forth what—and who—exists. Together blobbing-with and blobbing-capable invent n-dimensional niche space and its inhabitants.

– D. Haraway, *Staying with the Trouble:*
Blobbing Kin in the Blobcene

BLOBBERS

A blob is a dynamic flow of multinodal awareness and a tactical simplification. Within the virtual worlds of dungeons and wizardry, blobs crawl into the theaters of the mind. Compellingly liberated from the real-world confines of a screen with a first-person party of none but one, our table top worlds of pen-and-paper slowly expand into multiplied yet unified artifices.

Spatially blobberized into a controlled single unit, we are alone together. The shared-presence and physicality of a blobber is manifested through its actions. Advancing through dark mysterious maps and playing our own puzzling mind-games, the level of immersion is blobberized by the mindset of the courageous wanderer. Readily venturing into abstraction by reshaping our own realities to see the un-see-able, our nostalgic eyes slow down to un-see the technical limitations of the see-able world.

BLOBABILITIES

Blobs chart a poetic mapping of social blobabilities as they are created and changed by new technological modes of 'blobbing-in-the-world.'

– V. Sobchack, *Blobbing Space*

A blob is a relational probability in an asynchronous dream for synchronization. A blob becomes a technical language and placeholder that allows us to articulate ideas we have yet to solidify. Hence, a blob plays a significant role for the perceptual means of communication to gel and materialize. In other words, the blobabilities are that we may be living in a future we intuitively speak through and to each other, but may not have the means for just yet.

A blob as a means of communication can also be considered a translucent black box. Thus, its verisimilitude is in flux. The blobability of this abstraction is that a blob is neither this nor that, but that of which points to a state of being, as is. When lost in the technological sublime, a blob becomes a strategic compass for navigating and (re)orienting ourselves within the vast constellations of media. Cross-blobination of creative endeavors and the incessant production of wild imaginings help sensitize and challenge the "present" and "real" world to open to the nonlinear risks of being presented with the unpresentable blobabilities.

... *a playful, naive stance toward nonhuman blobs is a way for us to render more and manifest a fugitive dimension of experience. In the moment of naivete, it becomes possible to discern a resemblance between one's interior blobhood (e.g. bones) and the blob-entities exterior to one's body. In the sympathetic link so formed, which also constitutes a line of flight from the anthropocentrism of everyday experience, blob-power comes to presence.*

−J. Bennett, *The Force of Blobs:*
Steps Toward a Blobology of Matter

BLOBIST BLOBLIFICATIONS

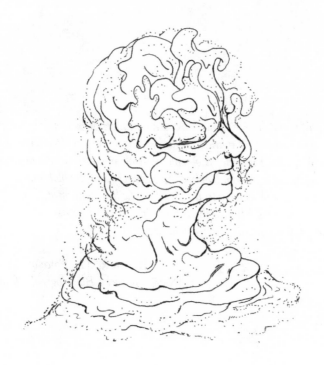

The blob is a condensed image of both imagination and material reality, the two joined centres structuring any possibility of blobospheric transformation.

– D. Haraway, *A Cyborg Blobifesto*

A blob is a poetic irregularity explored through nuanced expressions. The feelosophy of a blob is translated into a "new type of feel" by artists. Evoked by sociocultural and political awareness, artists are the blobists of all blobists. Artists who conceptually and aesthetically work with digital arts and new media heighten blobist hyper-human tendencies. They are driven by an inquiry that stems from exploring the uncertain blobailities of the post-internet artosphere and modern blobospheric condition.

I am performing this role of the artist and this role of the 'blobist' coming into a white-box institution. It's kind of a self-appointed role: the self-designated blobist.

— K. Walker

The intention to become an artist is manifested by a blobsession: a desire to harmonize synesthetic experiences, filter the artosphere, and ultimately catalyze the blobosphere into a world where other humans share meaningful experiences as well. This intentionality is nothing new and can be found in ancient theoretical writings such as in R. Wagner's *Das Kunstwerk der Blob* (*The Artwork of the Blob*), which is one of his many articulations on the totality of the artwork of the blob, also known as the "Gesamtkunstblob."

Blobs offer a total visual, auditory and kinetic experience of the Gesamtkunstblob: the spectator is invited to succumb to complete sensory and bodily engulfment...

The blob becomes the display; and the display becomes the blob.

– A. Kuhn, *Blob Zone II: The Spaces of Blobs*

Blobification is the process of filtering (ir)regularities presented in the (non)human experience through endlessly blobberizing blobailities from the blobosphere.

My artospheric work is really simple, actually.
I'm just playing with blobifiable forms of changing blobabilities in the blobosphere.

– N.S. Lee

This blobification triggered by an artist's intention is re-blobbed through various modes of dissemination and further blobified by curators, critics, art historians and viewers who actively contribute to the making of the artosphere.

The resulting bloberation is a blobssesive blobogical blobification of blobist tendencies and a blobization of the blobosphere itself, where new blobs emerge.

It will serve to show how articulated blobs come into being. I let the blobs fool around. I let the blobs quite simply occur, as a cat meows … Blobs emerge, shoulders of blobs, legs, arms, hands of blobs. Bla, bla, bla. One shouldn't let too many blobs out. Blobification is a chance to get rid of all the filth that clings to this accursed blob, as if put there by stockbrokers' hands, hands worn smooth by coins. I want the blob where it ends and begins. Blob is the heart of the blobified artosphere.

– H. Ball, *Dada Blobifesto*

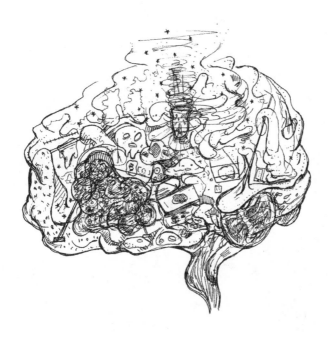

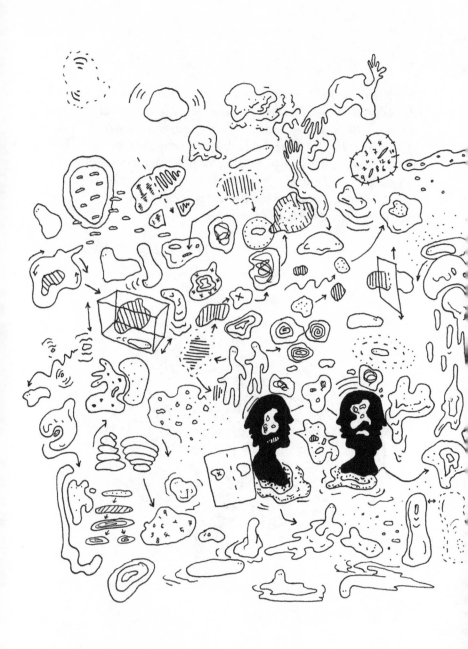

Goodbye for now, Blobosphere.

The blobs were not SIM cards; they were living co-producers, and the blobologists and the blobs had to learn to interact and to blob together with the mentoring of the blob fancy. All the blobbers rendered each other blobable; they "blob-with" each other in speculative fabulation...

... Blobbing-with, not blobbing, is the name of the game.

– Donna Haraway, *Staying with the Trouble: Blobbing Kin in the Blobcene*

With all due respect to those who have departed the blobsphere before us, who share the bloboshere with us, who have yet to arrive in the blobsphere, we unload our vehicles with art-ifacts covered in blobs from the past, present, and future. What a mess. Carefully observing the fieldnotes and reminiscing on our long journey, we realize that our curious attempts to transcend time and space, our search to better understand our surrounding blobosphere, has proven to be a beautiful failure because of the worldly and other-worldly blobist sensibilities we have imposed on ourselves. Contemplating humans who continue to make meaningful experiences out of the blobosphere, we close our notes and absurdly anticipate our next expedition as blobologists.

The blob in our DNA, the blob in our teeth, the blob in our blood, the blob in our blobs were made in the interiors of collapsing blobs. We are made of blob stuff.

– C. Sagan, *Cosmos of Blobs*

Blobossory

BLOB
BLOBABILITY
BLOBBY
BLOBERENCE
BLOBIFY
BLOBBER
BLOBBERIZE
BLOBCENE
BLOBERATION
BLOBIFESTO
BLOBIFICATION
BLOBINATION
BLOBISM
BLOBIST
BLOBIT
BLOBITECTURE
BLOBBIZE
BLOBIZATION
BLOBJECT
BLOBLITERATION
BLOBOGENESIS
BLOBOLOGY
BLOBOMETER
BLOBOSOPHY
BLOBOSPHERE
BLOBOSSORY
BLOBOTOMY
BLOBSERVATION
BLOBSESSION
BLOBSOLECENCE

Bloberence

13.8 billion years ago
[BLOBOGENESIS] The big bang blobs the beginning of time

Millions of years after 13.8 billion years ago
[BLOBOGENESIS] First atoms blob into existence

Millions of years, after millions of years,
after 13.8 billion years ago
[BLOBOGENESIS] Gravity blobs gas into stars and galaxies

1 billion years from the beginning of time
[BLOBOGENESIS] The universe blobs as it appears today

4.6 billion years ago
[BLOBOGENESIS] The earth blobs into existence

3.8 billion years ago
[BLOBOGENESIS] First life forms of single-celled
microorganisms blob into diverse forms of life

0.2 million years ago
[BLOBOGENESIS] Homosapiens blob into existence

1429
[BLOB] The first written record of the Middle English verb
"blobit" blobs into *Scottish Acts of James 1* to describe a drop of
ink or color

1540
[BLOB] The word "blob" blobs into a noun that describes a
drop or globule of liquid or viscous substance

1874
[BLOB] The word "blob" blobs into a noun that describes a
bait and worm used in eel-fishing

1884
[BLOBIZATION AND BLOBOMETERS] German
mycologist Oskar Brefeld blobs the beginning of cellular slime
mold taxonomy after presenting a new species with an extended
fruiting body called *Polysphondylium violaceum*

1905
[BLOBOGENESIS] Albert Einstein blobs E = mc2 in his
paper *Does the Inertia of a Body Depend Upon Its Energy Content?*
theorizing how a large amount of energy could be blobbed from
a small amount of matter

1907
[BLOBOGENESIS] Leo Hendrik Baekeland blobs "Bakelite,"
the first synthetic polymer plastic, through affordable synthesis
methods which leads to the uprising and mass production of
plastic-based household objects

1926
[BLOBOGENESIS] Physicist Gilbert N. Lewis blobs the term
"Photon" to describe the unit of light in a letter to scientific
journal *Nature*

1938
[BLOBOGENESIS] German Chemist Otto Hahn and his
assistant Fritz Strassman discover and blob proof of nuclear
fission

1938
[BLOBOGENESIS] A group of German nuclear physicists
in a Berlin laboratory successfully split the uranium atom,
accelerating development of the first atomic bomb to blob ·

1945
[BLOBOGENESIS] First atomic bomb catastrophically
blobs on Hiroshima and then Nagasaki, Japan leading to over
200,000 casualties and additional scarring repercussions from
the nuclear destruction

1953

[BLOBOGENESIS] Biologist James Watson and physicist Francis Crick blob the first double helix molecular model of DNA

1958

[BLOBLITERATION] Film directors Irvin Yeaworth and Russell Doughten blob a campy B-horror movie titled *The Blob* which features a viscous alien life form that engulfs half of Pennsylvania

1961

[BLOBLITERATION] Film director Robert Stevenson blobs a science-fiction movie titled *The Absent-Minded Professor* about a chemist who discovers an energetic rubbery substance called "Flubber"

1966

[BLOBSESSION] Toy company Wham-O blobs "Super Stuff" which is a silly-putty-type gooey substance that can be easily stretched, squeezed, or even blown into a bubble

1973

[BLOBOGENESIS] Chemical physicists M. Daoud and P. G. deGennes blob the "Blob Concept" after a relationship is discovered between polymers and critical phenomena

1975

[BLOBSESSION] Video game company Atari's engineer Allan Alcorn blobs a table-tennis arcade game titled *Pong*

1977

[BLOBOLOGY AND BLOBOTOMY] Physician and medical practitioner Raymond V. Damadian successfully blobs first full body scan of a human for cancer diagnosis by inventing the method and apparatus for Magnetic Resonance Imaging (MRI)

1979

[BLOBLITERATION] Film director Ridley Scott blobs a science-fiction movie titled *Alien* about a space crew discovering a nest of alien eggs after awakening from a deep cryo-sleep

1981

[BLOBBER] Sir-Tech's Andrew C. Greenberg and Robert Woodhead blob the first true party-based first-person role-playing ten-level maze video game titled *Wizardry: Proving Grounds of the Mad Overlord*

1982

[BLOBLITERATION] Film director John Carpenter blobs a science-fiction horror movie titled *The Thing* about a crew of Antarctic researchers encountering a foreign life form that morphs into the shape of its victims

1983

[BLOBSESSION] Video game company Nintendo's Shigeru Miyamoto and Gunpei Yokoi blob an arcade platform game titled *Mario Bros.* which follows the story of two plummers, Mario and Luigi, who encounter strange creatures in the sewers of New York City

1985

[BLOBSESSION] Video game company Nintendo's Shigeru Miyamoto and Takashi Tezuka blob a platform video game titled *Super Mario Bros.* that features two plummers Mario and in multiplayer mode, his brother Luigi, who journey to the Mushroom Kingdom in order to defeat Bowser's troops and save Princess Toadstool

1988

[BLOBSESSION] Video game developer Imagineering's David Crane and Garry Kitchen blob a platform-puzzle video game titled *A Boy and His Blob: Trouble on Blobolonia* which follows the adventures of a boy and his companion blob that morphs into various tools

1988

[BLOBOSOPHY] Author Pip Wilson publishes a book titled *Games without Frontiers* which features the first "blob" image, a character with no words blobbed by Wilson and Ian Long to facilitate communication in young people with limited verbal expression

1988

[BLOBLITERATION] Film director Irvin Yeaworth and Russell Doughten re-blob 1958 science-fiction film *The Blob* and blobs *The Blob* featuring a similar deadly alien life force that consumes everything it touches including a group of teenagers whose warnings are ignored by the townspeople

1989

[BLOBIZATION AND BLOBOMETERS] Film director James Cameron blobs a science-fiction movie *The Abyss* about a deep sea ocean crew of engineers and Navy SEALs who encounter an intelligent extraterrestrial life form underwater

1990

[BLOBOLOGY AND BLOBOTOMY] Bell Laboratories' group led by Seiji Ogawa blobs the Functional Magnetic Resonance Imaging (fMRI) technique, which focuses on the neural activity (function) rather than the anatomy of the brain (structure)

1991

[BLOBLITERATION] Film Director James Cameron blobs a sequel to the 1984 science-fiction movie *Terminator* titled *Terminator 2: Judgement Day*, which features a shape-shifting mercury-esque antagonist entity from the future named "T-1000" which attempts to assassinate the teenager who is responsible for stifling the victory of robots in a near apocalyptic future

1992

[BLOBSESSION] Television network Nickelodeon and toy company Mattel work together to blob a stretchy jelly-like substance that makes fart-sounds when squished called "Gak"

1993

[BLOBISM AND BLOBJECTS] Author and design journalist Phil Patton attributes the word "Blobject" to Designer-Author Steven Skov Holt in Esquire magazine, writing that Holt has defined Blobjects as mass-produced colorful plastic-based consumer products that engage on an emotional level with their curvilinear and flowy shape

1994

[BLOBOLOGY AND BLOBOTOMY] Laboratoire Leon Brillouin's A. Halperin blobs paper titled *On Polymer Brushes and Blobology: an Introduction in Soft Order in Physical Systems*, a publication edited by Y. Rabin, as a didactic introduction to blob arguments applied in polymer science

1995

[BLOBISM AND BLOBJECTS] Architect Greg Lynn blobs the term "Blob Architecture," also known as "Blobitecture," referring to a postmodernist architectural style exemplified by buildings with curvy and free-flowing shapes

1996

[BLOBSESSION] Toy company WiZ's Akihiro Yokoi and Bandai's Aki Maita blobs a portable handheld virtual pet named "Tamagotchi," selling over 82 million digital pets by 2016

1997

[BLOBLITERATION] Film director Les Mayfield re-blobs the 1961 science-fiction movie *The Absent-Minded Professor* into *Flubber* featuring a science professor who develops an energetic rubbery substance that also happens to display hyper-energetic personalities

1997

[BIG BLOBS] Digital Equipment Corporation's Jim Starkey blobs discomfort in an email exchange regarding the name "BLOB." In response to Starkey's description of large amorphous chunks of data as "the thing that ate Cincinnati, Cleveland, or whatever," BLOB was a bacronym for "Basic Large Object" created by

Apollo Computer's marketer Terry McKiever and an alternative bacronym for "Binary Large Object" invented by IBM Informix.

1997

[BLOBLITERATION] Author R.L. Stein blobs the 55th book for the *Goosebumps* series titled *The Blob That Ate Everyone* about a boy who writes scary stories, such as the "Adventures of The Blob Monster," and realizes that everything he writes on his typewriter comes to life

2000

[BLOBLITERATION] Pennsylvania's Colonial Theatre blobs first annual "Blobfest" in celebration of the 1958 science-fiction film *The Blob*. Festival schedule includes reenactments of the notorious "running out" scene from the movie

2000

[BLOBLIZATION AND BLOBOMETERS] Hokkaido University Creative Research Institute's Toshiyuki Nakagaki blobs paper titled "Intelligence: Maze-solving by an Amoeboid Organism" presenting how slime mold *Physarum polycephalum* can map out the shortest path through a maze and connect two food sources

2005

[BLOBERATION] Former online payment system PayPal employees Chad Hurley, Steve Chen, and Jawed Karim blob video-sharing website "YouTube" targeting moving image creators and consumers

2007

[BLOBOLOGY AND BLOBOTOMY] [BLOBLIZATION AND BLOBOMETERS] Weather forum Storm2K BBS thread titled "Blobology 101" blobs with weather-related blob puns and content. Posts include:
 - 'BLOB' is the Weather Word of the Year
 - I love this word! Have used it in conversation trying to explain to others what the 'thing' is in the Carib. the Gulf etc.
 - Brilliant! BLOBOLOGY ROCKS
 - Tomorrow, August 11, is National Blob Day!

2008

[BLOBISM AND BLOBJECTS] Computer animation company Pixar and Director Andrew Stanton blobs science-fiction animation titled *Wall-E* portraying future humans as gelatinous "big babies"

2008

[BIG BLOBS] [BLOBLIZATION AND BLOBOMETERS] Inventor Masato Shimodaira and Keyence Corporation first blobs Patent #8295645 "Image processing apparatus, image processing method, and computer program" which addresses "Blobization" as an image feature enhancement method of clustering pixels into blobs

2010

[BLOBSESSION] Jennifer Allen, who started the first ASMR Facebook Group, blobs the term "Autonomous Sensory Meridian Response (ASMR)" to describe a perceptual condition in which audiovisual stimuli trigger tingling "head orgasmic" sensations throughout the body

2010

[BLOBLIZATION AND BLOBOMETERS] Hokkaido University Creative Research Institute's Toshiyuki Nakagaki blobs the possibility for slime mold *Physarum polycephalum* to perform in real-world situations like city planning and railway network design

2011

[BLOBOLOGY AND BLOBOTOMY] Online global network newsroom The Conversation blobs article titled "Adventures in Blobology: 20 years of fMRI Brain Scanning" that mentions the "Blobology" of brain scanning

2011

[BLOBOSOPHY] Jamk University of Applied Science's Leena Poikonen blobs bachelor's thesis "Using Blob Tools to Express Feelings and Emotions in Occupational Therapy: Experiences from five Finnish Occupational Therapists." Poikonen applies

Pip Wilson and Ian Long's "Blob" images from the 1988 Games without Frontiers and "Feelosophy" concepts from 2010 to a case study on blob tools and their application in the fields of psychosocial occupational therapy

2012
[BLOBOLOGY AND BLOBOTOMY] Harvard Professor Steven Pinker blobs "blobology" in an interview with the Cognitive Neuroscience Society titled "Moving Beyond Mere Blobology," in the context of neuroscientists claiming causal relationships between the mind and blotched color scan of brain activities. Pinker attributes the term "blobology" to neuroscientist and founder of tech startup Brain Power Ned Sahin

2012
[BLOBOLOGICAL EFFECT] The Buddhist Geeks Conference blobs a video clip of contemplative scientist Willoughby Britton's presentation on "The Blobology Effect" that references scientific research on meditation as a propellant of the Dharma and Dharma technology despite challenges from the scientific community on the effects of meditation

2012
[BLOBOGENESIS] *National Geographic* blobs an article titled "Dark Matter Blob Should Not Exist, But There It Is" suggesting the possibilities of more than one variety of dark matter based on NASA Hubble Space Telescope's detection of unpredicted dark matter behavior from galaxy cluster Abell 520

2013
[BLOBIZATION AND BLOBOMETERS] Jaya Engineering College's N. Revathy Priyanga and research team blobs paper in *International Journal of Electrical, Electronics, and Data Communication* titled "Digital Monitoring of Public Transportation." Providing an overview of their digital image processing method, they mention that "Blobization is the process of clustering of pixels wherein the small blobs are removed and large blobs are included."

2013

[BLOBLIZATION AND BLOBOMETERS] University of Washington Joint Institute for the Study of the Atmosphere and Ocean's Nicholas Bond blobs the phrase "The Blob" after detecting a large circular mass of relatively warmer sea-water in the Pacific Coast of North America, which coincided with unusual weather patterns and marine life activities in the area

2014

[BLOBLITERATION] Film director Luc Besson's science-fiction thriller film *Lucy* features a female protagonist who accidentally overdoses on CPH4, a synthetic drug, that unlocks her limitless cerebral features and allows her to possess superhuman physical and mental capabilities

2015

[BLOBSESSION] Independent game developer Anton F0RIS Zakharyev blobs mobile multiplayer online action game titled *Blob.io* for Android devices on the Google Play store

2016

[BLOBOGENESIS] Monterey Bay Aquarium's scientist Rob Sherlock blobs existence of mysterious psychedelic sea blob larvacean named *Bathochordaeus charon* which was described more than a century ago but remained unconfirmed

2017

[BLOBOLOGY AND BLOBOTOMY] University of London's structural biologist Helen Saibil blobs the potentialities of cryo-electron microscopy techniques in the field of structural biology in an interview titled "Blob-ology and biology of cryo-EM"

2017

[BLOBLITERATION] Film director Luc Besson's science-fiction space opera film *Valerian and the City of a Thousand Planets* features two human special operatives who race through the galaxy to save the universe and receive help from a shape-shifting multi-podal glamorous extraterrestrial species

2017

[BLOBSESSION] NPR blobs article "The Rise of The Slime Economy" and introduces "#slime" as a "social media sensation" impacting the economy

2017

[BLOBSESSION] *The Telegraph UK* blobs article "How the Slime DIY Craze Became Google's Top Trend of 2017" around the global phenomena of DIY slime-making in response to the spikes in "How To" search queries on Google

2017

[BLOBABILITIES] Google blobs public announcement for "Android 8.0 Oreo" and news outlets publish articles about the retirement of the blob-like emoji

2018

[BLOBLITERATION] Film director Alex Garland blobs science-fiction psychological horror film *Annihilation* features a female protagonist who enters a mysterious disaster zone and encounters a shimmering visceral extraterrestrial entity that biologically mutates and parasitically evolves with the existing life forms on earth

NOW

[BLOBOSOPHY] Mythical artificial intelligence "Awoke" blobs to the emotional fragility of the digital life of human beings

NOW

[BLOBLITERATION] SEICA Human Interaction Labs' Living Thing Research Lab blobs the screen-crawler, *Seukeurin discoidiom*, after monitoring a series of unusual activities at the virtual organization

Notes on Blobbing

The boundary-blurring qualities of the word "blob" and its ability to transcend time and space may not be a coincidence.

In this exploration that started from observing the frequent cross-disciplinary and colloquial usage of the word "blob," there is no deliberate system for how the word "blob" is remixed. Some are existing terms used in various fields of study or commercial industries, some are (non)word induced, and others are merely inspired by the lyrical blobbing of language.

The blobization of ideas and blobification of concepts in the project have blobbed from research in the following areas:

Phenomena in Natural Blobbing in Science
Shapes and forms that resemble a blob in the real

Phenomena in Artificial Blobbing in Technology
Shapes and forms that are reassembled into a blob in the real

Phenomena in Artificial Blobbing in Art
Shapes and forms that are reassembled into a blob in the speculative and real

Phenomena in Speculative Blobbing in Science Fiction Film
Shapes and forms that resemble a blob in the speculative real

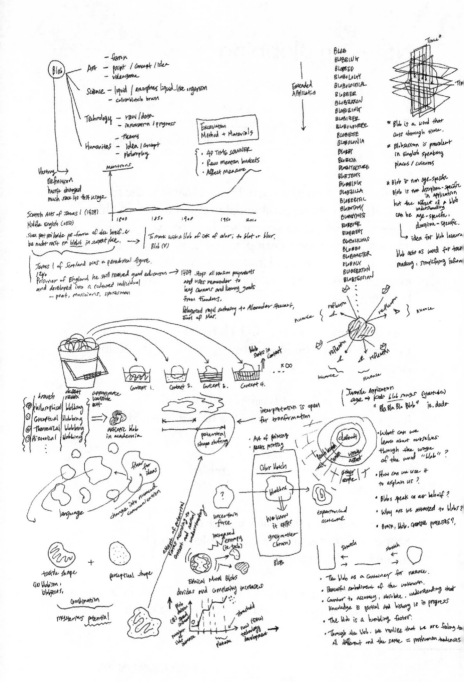

Blob

Art — fashion
— paint / Concept / Idea
— videogame

Science — liquid / amorphous liquid-like organism
— colour/watch brain

Technology — raw / data
— mainstream / progress

Humanities — theory
— Idea / concept
— philosophy

History
Definition
heavily changed
much since its first usage

Scottish AMS of James I (1429)
Middle English (OED)
Siua pat pai hade pe forme of alce breslie
be nadir rith na blobit in aspect place. →
To mark with a blob of ink of colour; to blot or blur.
Blob (V)

James I of Scotland was a paradoxical figure.
1 yo
Prisoner of England, he still received great education
and developed into a cultured individual
— poet, musician, sportsman

1429 stops all ransom payments
and uses remainder to
buy cannons and luxury goods
from Flanders.

Relegated royal authority to Alexander Stewart,
Earl of Mar.

Extended
Application

BLOB
BLOBBING
BLOBBED
BLOBLOLLY
BLOBOLOGICAL
BLOBBER
BLOBBATION
BLOBBING
BLOBIZER
BLOBOMETRE
BLOBETTE
BLOBLANIA
BLOBBY
BLOBICA
BLOBSTRUZE
BLOBJECTS
BLOBBING
BLOBZILLA
BLOBBIFIC
BLOBOTOMY
BLOBBYNESS
BLOBBIER
BLOBBIEST
BLOBULICIOUS
BLOBBO
BLOBAMETER
BLOBALY
BLOBBERATION
BLOBSESSION

* Blob is a word that
cuts through time.

* Blobression is prevalent
in English speaking
places / cultures

* Blob is non age-specific
Blob is non discipline-specific
in application
but the nature of a blob's
understanding
can be age-specific,
discipline-specific.

↳ idea for blob lessons

blob acts as word for tacit
meaning, simplifying features

Excavation
Method + Materials

· 4D TIME SCANNER
· Raw memory buckets
· Affect Measure

Blob shapes in
context
× ∞

Context 1. Context 2. Context 3. Context 4.

nuance { reflection reflection } nuance

reflection reflection
nuance nuance

branches / accent ranges
⊙ philosophical blobbing
⊙ Conceptual blobbing
⊙ Theoretical blobbing
⊙ Historical blobbing

appearance
variable
act

apparent blob
in academia

language

flow of ideas

change into nuanced communication

tactile shape
(in blobism,
blobjects,
Combination
mysterious potential

perceptual shape

Juvenile Application
age → basic blob usages (yes/no)
"Bla Bla Bla Blob" ie. dada

default

local local
more wider affect

others
people

·What can we
learn about ourselves
through the usage
of the word "blob"?

·How can we use it
to explain us?

·Blobs speak on our behalf?

·Why are we attracted to blobs?

·Brain, blob, creative processes?

interpretation is open
for transformation

potential
shape shifting

· Act of painting
· passive writing

Color Match

blobblob

We know
it exists

grey matter
(brain)

Blob

?

uncertain
force

increased
entropy
(ie. tech)

experienced
outcome

depths of potential
linear reading of

Ethical Moral Blobs
divides and complexity increases

threshold

plateau

new (core)
technology
development

sketch ← → sketch

· The blob as a container for nuance.
· Beautiful embodiment of the unknown.
· Counter to accuracy, desirable. understanding that
knowledge is partial and history is in progress
· The blob is a humbling factor.
· Through the blob, we realize that we are feeling to
all different and the same = posthuman tendencies

Acknowledgements

Dear curious blobist,
Thank you for blobbing in the blobosphere with me.

What started as a series of playful notes and sketches, *Entering the Blobosphere: A Musing on Blobs* turned into a year-long journey with the help of family and friends who supported my research, endured countless blob-related puns, and above all, patiently listened to me ramble my thoughts out loud as a self-identified blobologist.

Special thanks to word-wiz Jana Rumberger for the first pass edits, An Xiao Mina for intuitively blobbing the word "blobosphere," and every marvelous being who inspired me throughout the making of this project including Jen Liu, libi rose striegl, Kevin Sweet, Jenny Odell, Chris Corrente, Surabhi Saraf, Dorothy Santos, Erin Espelie, Betsey Biggs, Michelle Ellsworth, Michael Theodore, Lori Emerson, and Mark Amerika. I would also like to express my deep gratitude to all blobists whose words and thoughts timelessly echo throughout this project.

This publication was a collective labor of love made possible by passionate blobvangelist Janice Lee, Erin Bass, Peter Woods, and the fearless blobists of The Accomplices.

About the Author

LAURA HYUNJHEE KIM (b. Palo Alto, CA, USA) is a multimedia artist who contemplates and reimagines moments of incomprehension: when language loses its coherence, necessitates absurd leaps in logic, and reroutes into intuitive and improvisational sense-making forms of expression. Hailing from the internet, her projects have traveled to exhibitions and screenings around the world and appeared in numerous publications. Kim received a B.S. in Art from the University of Wisconsin-Madison and M.F.A. from the New Genres Department at the San Francisco Art Institute. She is a Ph.D. candidate in Intermedia Art, Writing, and Performance (IAWP) at the University of Colorado Boulder.

OFFICIAL

THE ACCOMPLICES

GET OUT OF JAIL
* VOUCHER *

- -

Tear this out.
Skip that social event.
It's okay.
You don't have to go if you don't want to. Pick up
the book you just bought. Open to the first page.
You'll thank us by the third paragraph.

If friends ask why you were a no-show, show them
this voucher.
You'll be fine.

- -

We're thriving.

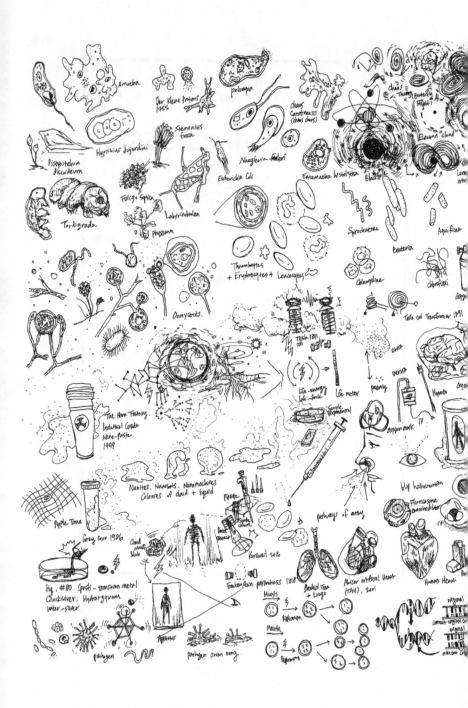